The Hard Good

STUDY GUIDE + STREAMING VIDEO

The
Hard
Good

Showing Up When
You Want to Shut Down

STUDY GUIDE + STREAMING VIDEO
SIX SESSIONS

LISA WHITTLE

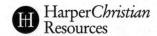

HarperChristian
Resources

The Hard Good Study Guide

© 2021 by Lisa Whittle

Requests for information should be addressed to:
HarperChristian Resources, 3900 Sparks Dr. SE, Grand Rapids, Michigan 49546

ISBN 978–0–310–13864–8 (softcover)

ISBN 978–0–310–13865–5 (ebook)

HarperChristian Resources titles may be purchased in bulk for church, business, fundraising, or ministry use. For information, please e-mail ResourceSpecialist@ChurchSource.com.

The author is represented by Alive Literary Agency, www.aliveliterary.com.

First Printing June 2021 / Printed in the United States of America

To my many incredible sisters out there, allowing Jesus to make much of your life despite the hard: you inspire me. I'll never forget the stories you've told me at conferences, in DM's, emails, and over coffee. Most of all, know that He has seen every tear.

And to my sister, Kat Armstrong, whose fingerprints are all over this study guide: Thank you for your invaluable contribution. You have made it richer by your commitment to the Word of God and belief in this message. Thank you for loving and believing in me, as a friend. I feel more than blessed to have had such an astute student of the Bible and incredibly gifted woman as a vital contributor to this project.

Contents

Thanks for Showing Up
(A Message from Lisa)

My friend, I do not take it lightly that you are here for this study in the midst of your busy schedule. Life gives us plenty of opportunities to push necessary healing aside by providing overload and weariness, but I'm so glad you have chosen this pursuit. My prayer is that this study will not deplete you, but instead, strengthen you. With God, hard things in life aren't for nothing if we stay in the process of transformation with Him.

Good news! We have a lot of incredible progress ahead of us in the next six weeks. I am so excited about what God is going to do in our midst. We are going to look at two kings, predominately: Saul and David—and in each of them, there is so much us. But I ask you not to be afraid if you find yourself resonating with Saul, more than you even hoped. While David may be the person we wish to be, Saul is much more often a picture of how we are. The amazing thing about having examples in the Bible we can identify with is for this very purpose: reflection, that we might be able to spot important places to become more, better, different with the help of God.

As we start this study, know that you are not alone. We are a tired bunch, and I don't just mean needing sleep. We are worn down by life. We are brokenhearted and yet still, trying our best. We share that same frustration of dealing with growth-stunting internal issues, over and over without getting anywhere. We all want to get close to God or we wouldn't be here. I take those things seriously. I wouldn't dream of wasting your valuable time if I didn't think this study could truly help you.

The struggles to live in this world full of hardships, including the battle within our own minds and hearts, is real.

But even as we share that community, I want us to look forward with hope: to learn the true, biblical definition of good. To be able to see our hard places and instead of letting them overtake us, let God do a work inside of us to help us live the future-focused words, "what now?" To watch us become God's woman in a new way—more Kingdom usable than we've ever been before.

These are the things (and more) *The Hard Good* study is here for.

I am praying, even now, that this study will serve you well—in the difficult places of your past you struggle to reconcile . . . the current tough spots you find yourself in . . . and the things you so deeply want to break free from that chip away at the abundance of life God offers you but you can't seem to grab onto.

May He meet you here, from the very start.

Jesus is Everything.

How to Use This Guide

RESOURCES

- All-in-One Study Guide/Video Access: For your greater convenience with this study, you will only need *The Hard Good* study guide because it includes streaming video access (look on the inside cover). Your group can still use the DVD to watch the videos if you choose, but each participant will have access to all the video teachings with her study guide—for catch-up, refreshers, or those times months after a study has ended that you wish you could go back and hear that one session teaching again!
- Book: *The Hard Good*: Although optional, you are encouraged to have a copy of *The Hard Good* book, as the book and guide were designed together to help you with deeper insights.

GROUP DISCUSSION

Because real growth in any study happens during your small-group time, in addition to Lisa's video teaching, each session includes group discussion. You'll be able to process what you're learning, ask questions, and learn from group members too. In addition,

you'll have an opportunity to pray as a group and read Scripture together. This study guide includes group discussion elements we think will be a bonus to your group dynamics.

1. Group prayers. Your whole group can read aloud the prayers, which encourage and equip women to value prayer and learn to pray out loud.
2. Scripture reading from select Psalms. Since most of this study will be on the life of Saul and David, we've chosen a psalm of David that can be read together as a group before the video teaching as a way to unify our hearts as we prepare to study.
3. Prayer blessings. At the end of each session, you'll see a prayer for the group leaders to pray over all the group members. This is an opportunity for you to experience what it is like to receive blessings prayed over you. According to Baker's *Evangelical Dictionary of Biblical Theology*, "the blessing served as a guide and motivation to pursue a course of life within the blessing."[1]

PERSONAL STUDY

The personal study lessons are designed to get you into God's Word to study the life of Kings Saul and David from the book of 1 Samuel. Your three-part Bible lesson can be completed between group sessions. Each lesson will take approximately 45 minutes of total individual study time divided into three 10–20-minute parts. It's up to you whether to work through the material one part at a time over the course of a few days or all in one sitting. Do what's best for your schedule and learning style.

RED THREAD REALITY

Every personal study session will end with a few notes about the passages you've been reading and studying. This will offer some deeper biblical insights, context, and background to help define that red thread that connects all of God's Word to Jesus as well as connecting us to it.

GROUP LEADERS

Check out the leader's guide in the back of this book for tips on creating environments where every group member feels safe to be honest and to grow spiritually.

Getting Out of Your Own Way
Group Time

PRAY

Pray aloud as a group.

> Lord, I want to show up for my life, even when things are hard. I need
> Your peace and strength. Be near to me when things get uncomfortable.
> Assure me of Your love. Use this time with my sisters to build my faith.
>
> Spirit of God, be my counselor as I study the Bible.
> In Jesus' name, amen.

SHARE

Take a few minutes to go around and allow group members to introduce themselves and answer the questions below.

1. What brought you to this group?
2. What do you hope to gain from this study?

 ## READ

Invite someone to read aloud as group members prepare their hearts for Lisa's teaching.

Psalm 25

Theme: A prayer for defense, guidance, and pardon.

A Psalm of David

¹ In you, Lord my God,

 I put my trust.

² I trust in you;

 do not let me be put to shame,

 nor let my enemies triumph over me.

³ No one who hopes in you

 will ever be put to shame,

but shame will come on those

 who are treacherous without cause.

⁴ Show me your ways, Lord,

 teach me your paths.

⁵ Guide me in your truth and teach me,

 for you are God my Savior,

 and my hope is in you all day long.

⁶ Remember, Lord, your great mercy and love,

 for they are from of old.

⁷ Do not remember the sins of my youth

 and my rebellious ways;

according to your love remember me,

 for you, Lord, are good.

⁸ Good and upright is the Lord;

 therefore he instructs sinners in his ways.

⁹ He guides the humble in what is right

 and teaches them his way.

¹⁰ All the ways of the Lord are loving and faithful

 toward those who keep the demands of his covenant.

[11] For the sake of your name, Lord,

 forgive my iniquity, though it is great.

[12] Who, then, are those who fear the Lord?

 He will instruct them in the ways they should choose.

[13] They will spend their days in prosperity,

 and their descendants will inherit the land.

[14] The Lord confides in those who fear him;

 he makes his covenant known to them.

[15] My eyes are ever on the Lord,

 for only he will release my feet from the snare.

[16] Turn to me and be gracious to me,

 for I am lonely and afflicted.

[17] Relieve the troubles of my heart

 and free me from my anguish.

[18] Look on my affliction and my distress

 and take away all my sins.

[19] See how numerous are my enemies

 and how fiercely they hate me!

[20] Guard my life and rescue me;

 do not let me be put to shame,

 for I take refuge in you.

[21] May integrity and uprightness protect me,

 because my hope, Lord, is in you.

[22] Deliver Israel, O God,

 from all their troubles!

 # LEARN

Session 1 Video Teaching (12:00 min.)

Gather your group together to watch Lisa's first video teaching. You can use the outline and notes sections below to keep track of what you are learning.

Date:_____

> **The real reason we don't seem to make traction in life is not because life is hard. It's because when life is hard we bail on God. God wants to take us through hard things and refine us through the process.**

How to show up for your life when life gets hard:
- Redefine "good" according to God's Word.
- Become aware of the "cycle of offense."
- Hard things → Anger/hurt → Offended → Progression is blocked.
- Make peace with your life.
- Stop running away.

Our hard places are helping us while we are looking to push them away.

Notes

 DISCUSS

Group discussion is the most important part of the study. Take 20–45 minutes to process what you are learning with your group.

1. Invite a group member to read John 16:33 aloud. As a group, collaborate on a list of all the things you know for sure about life based on John 16:33.

2. Name one hard thing in your life right now.

3. Invite a group member to read Romans 8:28 aloud. Based on Romans 8:28, how does this verse bring you hope about the hard parts of your life?

4. According to Lisa, there are some misleading messages floating around that counterfeit God's truth about our circumstance. Which of the following messages distract you the most? Check all that apply and share with your group.

 ☐ You can do hard things, in and of yourself.

 ☐ You are good, just as you are.

 ☐ You create your own "good" life.

5. According to God's Word, your Savior is helping you through the hard good. Which of the following Bible truths resonate with you the most? Share with your group.

 ☐ God is good. Therefore, hard things that lead you to God will be good for you.

 ☐ Growth is good. That means process and progress are important.

 ☐ A good life is one of Kingdom usability.

 ☐ I'm honestly struggling to believe anything good can come from the hard I'm experiencing.

 ☐ I have doubts and concerns, but I'm willing to give God a chance to bring the good from the hard.

6. How do you respond to God and others when you are frustrated with your life? How do you think that impacts their lives?

7. According to Lisa, making peace with life isn't about saying you agree with decisions that were out of your control; making peace with life means coming to terms with realities, doing your absolute best, and leaving the rest up to God. What might you be holding onto that you could release to God?

 PRAY

This prayer is for your group leader to pray over your group as a blessing. This is your opportunity to receive a blessing from the Lord before you pray for one another and take prayer requests. Prayer blessings are a biblical practice of loving others by calling on the Lord on their behalf.

Lord of transformation, help us embrace the change You want to bring to our lives.

Lord of comfort, comfort us when we feel uncomfortable with the refining process.

Lord of love, remind us, all things are working together for our good.

Spirit of God, do your good work in us; we're ready.

In Jesus' name, amen.

Group Prayer Requests

Use this space below to list your group members' prayer requests.

Pray as a group before you close your time together.

Getting Out of Your Own Way
Personal Study

 ## CONTEXT AND SETTING

If you've ever walked into a movie late, you know the frustration of coming into a scene you don't quite understand. Since movies at the movie theater don't hit the pause button when I need to go to the bathroom, I've even hesitated to drink too much while watching a movie in a theater, simply because I know even the 3–5 minutes I'll miss can be crucial for me to understand the context of what is actually happening in the story!

When it comes to studying biblical narrative, diving into a passage without proper context can make us feel like this and create problematic understanding. Context and setting are even more important because we are so far removed from the cultural traditions and lifestyles of the Bible. So, let's catch you up on where we are in God's story before we dive too deeply into the drama and lives of two major players, Saul and David.

The Bible is a collection of divinely inspired manuscripts written over thousands of years by at least forty different authors. Together, the manuscripts make up tens of thousands of verses, sixty-six books, and two testaments. But the Bible is really just one big story, God's story of redemption. From Genesis to Revelation we will encounter stories, songs, poems, wisdom literature, letters, and even apocalyptic prophecies. But all in all, everything we read is to help us understand God's love. I hope if you take only one thing away from this study or anything I ever write it will be this: His heart is for you.

Remember when I asked you to put your hand over your heart and notice your heartbeat? I know this may have felt silly, but I hope you indulged me by doing it, because it had a purpose. Sometimes we need physical reminders of things we take for granted in our daily lives. Feeling your pulse, noticing your breathing, recognizing that beating of your heart is an exercise in reminding ourselves of the proof that we are alive and seeing our very heartbeat as evidence of how much God loves us.

God's human project to see us flourish, has gone sideways in sin, however. That's why He sent His Son, Jesus, who lived and died and rose from the dead, to take on sin and make a way for us to stay in a loving relationship with a holy God. One day Jesus is coming back to make all things new, and when He does there will be no more hard. It will only be good. He brings good from the hard, but until then, we rely on God's Word for instruction, direction, and full confidence that we are not abandoned.

God's story of redemption starts with a man named Abraham being called by God to be a blessing to *all* people, but as the story goes, the plot has a lot of twists and turns including, but not limited to, war, famine, broken family relationships, and then the ruling of wicked judges. That brings us to our focus, the transition time in Israel's history from evil judges to an experimental monarchy in the book of 1 Samuel. Enter Saul, Israel's first king.

Read 1 Samuel 9:1–10:12.

1. What stood out to you most in this passage?

2. A lot is happening in these two chapters. In your own words, summarize the events leading up to Saul's anointing as king. What was going on in Saul's life? Was it exceptional or average or noticeable at all? Who are the players in this story?

3. List at least 10 things you learned about Saul in 1 Samuel 9:1–10:12.

Saul was just looking for his lost donkeys and ended up being anointed as the future king of God's people. No big deal, right? He went searching for lost property and came back with the task of launching an untried monarchy and carrying a whole nation on his shoulders. I feel a bit blown away just reading his story.

You might know a thing or two about showing up for something specific and inheriting unexpected responsibilities. Or maybe everything on your plate is exactly what you anticipated, but keeping all the plates spinning has become a challenge. Maybe right now you are in the middle of pursuing something with expectations and are just now realizing, you have no idea how "this" is going to turn out! As with Saul, God knows what He is assigning us to, and He's in every part of the assignment. We simply cannot choose our purpose or seek it hard enough to make it clear. We have nothing to do with our purpose, but everything to do with being available to be used!

4. Take a few minutes to list the roles or titles God has assigned to you and the responsibilities that come with each one:

Role/Title	Responsibilities

Now, circle the titles you never expected, but have found yourself wearing the "uniform and name badge" every day. Put an X next to the responsibilities you struggle with. This can be struggle because you feel ill-equipped, or it can be simply because the tasks are really hard. Listen, God knew when He put you inside those circles and He's got you at every X. He doesn't abandon us to our circumstances, He goes with us into them and remains there until we realize all we're really tasked with is showing up. Our responsibilities, joyful or burdensome, don't have the final word. God does.

And now I want to invite you to take at least one minute to write out a prayer to God about the role in your life that's heaviest on your heart. Be honest about your approach to this role and confess if you've assumed your own power in it. Ask God to meet your need and lead you. He will, friend. He put you there to begin with.

Date:_____

INTO THE SCRIPTURE

God provided many signs that Saul was called to kingship in 1 Samuel 10:3–9. Some were from Samuel's prophecies, some in the narrator's commentary, and some we can observe as readers.

Read 1 Samuel 10:3–9.

1. List all the reasons Saul was chosen to be the first king of Israel from 1 Samuel 10:3–9.

2. What evidence do you see in your own life that God is equipping you to be used for His glory and your good?

This had to be a lot to take in for Saul, but we know very little about what was going on in his heart and mind as he grappled with life-changing news. Although we cannot know for sure, it might help us to imagine Saul's internal dialogue as he absorbed his future as king.

3. How do you think Saul was processing all of this?

Read 1 Samuel 10:9–16.

Saul's life was not the only one being changed by the installment of the monarchy. His friends, family, and neighbors would also be processing the shift. Serving as the first king of Israel meant that Saul's life would be nothing like he had assumed, and it meant everyone around him would have opinions of the monarchy and all his decisions to come.

4. Based on 1 Samuel 10:9–16, what insecurities and concerns do you think Saul was dealing with?

Self-talk is that internal dialog you have with yourself, and while it can be positive or negative, studies have shown that most of our conversations with ourselves are not uplifting. Negative self-talk is certainly something I've struggled with in the past. Taking inventory of what we say and how we communicate to ourselves can be revealing and help us to course correct.

5. What internal dialogue best represents your self-talk? Check all that apply.

☐ I'm not as qualified as I should be. Someone else could do it better.

☐ I've messed up things like this before.

☐ I'm not sure I can live up to everyone else's expectations.

☐ I'm not sure I can live up to my own expectations.

☐ Life is just too hard.

☐ This could go wrong, and this could go wrong, and this could go wrong too.

☐ What if I heard God wrong and this isn't His plan for me?

☐ Other:

6. Why do you think Saul didn't tell his uncle about the matter of the kingdom?

7. Who's a safe person you could confide in when you are struggling with insecurities?

Saul conveniently skipped the part about being king when retelling his story to his uncle. We can't know for sure why Saul did this, but we will see as the story goes on that Saul really struggled with insecurities and often skipped out on the hard parts of life, work, and leading. As a result, Saul didn't allow God to transform his character. He just kept bailing when things got hard. The implications to our own life may feel a little too close for comfort, but stick with me here. Admitting our likeness to Saul can also lead us to seeing where we can take a better path. Though the world pitches to us gains of the tangible kind, the true goal of life isn't about getting better things; it's

about becoming a better person, more like Christ. In that spiritual formation process, we get the greatest thing, which is to be used by God for the Kingdom of God. In turn, this is what brings us the greatest measure of fulfillment.

8. Identify a few ways or circumstances you can see yourself being used by God right now. It might feel intimidating to even answer this, but really try to push through the initial hesitation you may have. Having the confidence to claim we are being used by God is half the battle; but this is something He wants for us.

9. Looking at your list, which circumstance are you most comfortable with? Why? Which are you least confident in? Why? Consider how Saul must have felt being told he would be the first king of Israel, and then consider how easy it can be to want to be something (an obedient servant to the Lord) but actually being it is much more difficult.

PERSONAL APPLICATION

Remember the cycle of offense from the video? Remember how we talked about how our surprise or disappointment can cause offense at things God never meant for us to be offended by, but really He meant for them to be portions of our transformation experience with Him? In case you forgot, here it is again:

Hard thing → Anger/Hurt → Offended → Blocked progression

The big question you have to answer today is this, "Am I offended by my life?"

I recognize that this is not easy and for good reason. It's a positive step to have to labor over an issue that is a potential game-changing breakthrough for you. If you find offense in your life, where is it coming from? What if by being willing to look at this right now you are breaking free from something that has stifled you for far too long? Do you believe that is possible? Why or why not?

See, the very things that Saul could not control were the things that kept him from realizing his potential as God's man. Every time something changed for Saul and God wanted to grow him through it, there was some form of resistance or disobedience. There are always two ways we deal with change—positively, or negatively, and two ways we receive it: through willingness or denial.

Read 1 Samuel 10:17–19.

1. As Samuel, the great priest and prophet of Israel, gathered all the people together for the announcement of Saul's kingship, there were different reactions to the news. In what ways did Samuel's announcement of Saul's kingship potentially work against Saul's ability to rule his people?

2. How could Samuel's announcement of Saul's kingship work for Saul's governance?

Read 1 Samuel 10:20–27.

Think about this passage for just a moment with me. Was Saul hiding *before* the gathering or *after* people were already huddled together? Did people see him hide? Is that how they knew where to find him? Was this common in this culture or just for Saul?

3. Now, let's revisit the cycle of offense for a minute and see if we can make better sense out of how Saul's actions might be more in line with our own than we realize. Can you define the cycle in terms of what you know of Saul's response to God's invitation to be his king? How did each step in the cycle reveal itself in Saul's story?

> **Hard thing** → _____
>
> **Anger/Hurt (aka Fear)** → _____
>
> **Offense** → _____
>
> **Blocked progression** → _____
>
> _____. _____. _____. _____

This story could also serve as a metaphor for so many of our chosen responses to being called out, but perhaps none quite like how we respond when we are unprepared or unwilling to lead.

Saul chose to hide when he should have been showing up in his life with the confidence that God had chosen him and that the people had begged for a king.

4. Why do you think Saul hid in the baggage? Can you relate? Why or why not?

5. Is there anything you are hiding or running from in life? If so, what would you feel comfortable sharing with your group? If not, what has helped you face your circumstances?

The truth is, you can't be used by God when you are hiding from your calling. You just can't. My friend, if you want true and lasting fulfillment in your life, you need to get out of your place of hiding and start living into your potential as a Kingdom builder. And please . . . don't overcomplicate this. There is much to do right around us. Saul teaches us an important lesson about how to respond to a call to lead at home, at work, or in ministry; turning away from God never bears good fruit. If He's chosen you to lead, He will equip you to follow through in His plan.

According to 1 Samuel 10:26–27, there were two types of men joining him on his way home to start his new role as king. List both types of men and write out how they responded to his leadership.

Type	Response

I feel for Saul. His position polarized people around him. His naysayers surely compounded his preexisting insecurities. Read how 1 Samuel 10:26–27 sheds light on Saul's response to the "scoundrels" who "despised him." In my translation (NIV) it says, "Saul kept silent."

6. What are you keeping silent about? What insecurities are keeping you from using your voice?

Remember, you will determine the extent of your usability for the Kingdom of God in how you respond to the process—just like Saul did. We all have the gift of free will, yes, even in the midst of hard circumstances.

And that is where this study starts: helping us get out of God's way and letting our hard circumstances be worked through for the good God intended.

RED THREAD REALITY

The book of 1 Samuel tells the story of four key people who each had hard good callings to respond to:

1. Hannah—Samuel's mom
2. Samuel—One of the priests and prophets in Israel
3. Saul—The hesitant and faltering first king of Israel
4. David—The imperfect man after God's own heart and the greatest king in Israel's long history

Like many of the Bible stories about great men used by God, this one begins with a godly woman's prayers. Hannah's story is found in 1 Samuel 1 and her prayer in chapter two "becomes a proleptic summary of the themes that fill the book as a whole: Hannah's prophetic son looks forward to the emergence of kingship in Israel, a victory David will live to celebrate as historical reality."[2]

Hannah's presence at the beginning of this book cannot be understated. In many ways she is supposed to point us to Mary of Nazareth, who also prayed an all-important prayer that led to another great man, Jesus.

Notice how these two women's famous prayers are linked.

Mary's prayer in Luke 1:46–55.

Hannah's prayer in 1 Samuel 2.

My soul glorifies the Lord and my spirit rejoices in God my Savior, for he has been mindful of the humble state of his servant. From now on all generations will call me blessed, for the Mighty One has done great things for me—holy is his name. His mercy extends to those who fear Him, from generation to generation. He has performed mighty deeds with His arm; He has scattered those who are proud in their inmost thoughts. He has brought down rulers from their thrones but has lifted up the humble. He has filled the hungry with good things but has sent the rich away empty. He has helped his servant Israel, remembering to be merciful to Abraham and his descendants forever, just as he promised our ancestors.

My heart rejoices in the LORD; in the LORD my horn is lifted high. My mouth boasts over my enemies, for I delight in your deliverance. There is no one holy like the LORD; there is no one besides you; there is no Rock like our God.

Do not keep talking so proudly or let your mouth speak such arrogance, for the LORD is a God who knows, and by him deeds are weighed.

The bows of the warriors are broken but those who stumbled are armed with strength. Those who were full hire themselves out for food, but those who were hungry are hungry no more. She who was barren has borne seven children, but she who has had many sons pines away.

The LORD brings death and makes alive; he brings down to the grave and raises up. The LORD sends poverty and wealth; he humbles and he exalts. He raises the poor from the dust and lifts the needy from the ash heap; he seats them with princes and has them inherit a throne of honor.

For the foundations of the earth are the LORD's; on them he has set the world. He will guard the feet of his faithful servants, but the wicked will be silenced in the place of darkness.

It is not by strength that one prevails; those who oppose the LORD will be broken. The Most High will thunder from heaven; the LORD will judge the ends of the earth.

He will give strength to his king and exalt the horn of his anointed.

The tension of the hard good is very present in the books of First and Second Samuel. We see 1 Samuel begins with Hannah's desire, but inability to have children carries throughout the book of 1 Samuel as the kings installed to rescue God's people fall short of their roles. The book is filled with examples of unrealized potential and a resistance to accept God's refining process, the same tensions we feel in the hard good process. Thankfully, none of the heartaches or sins of God's people and His leaders keeps them, or us, from experiencing God's grace.

What is the red thread reality? Tension is hard but endurance through tension is where good comes alive.

Becoming God's Woman
Group Time

PRAY

Pray aloud as a group.

> Lord, we want to be more like Jesus, even if Your good work involves my discomfort. Change us to be more Christlike. Help us commit to the process of change. When we're tempted to run away or look away, keep us focused on You. Thank You for Your grace, God.
>
> In Jesus' name, amen.

SHARE

Take a few minutes to review and share your answers to these questions from the personal study lessons in session 1. No judgment here for anyone who didn't complete the lessons.

1. What evidence do you see in your own life that God is equipping you to be used for His glory and your good? (page 13, session 1, Into the Scripture, question 2)

2. Is there anything you are hiding or running from in life? If so, what would you feel comfortable sharing with your group? If not, what has helped you face your circumstances? (page 19, session 1, Personal Application, question 5)

 READ

Invite someone to read aloud as everyone prepares their hearts for Lisa's teaching.

Psalm 39

Theme: Apart from God, life is fleeting and empty.

For the director of music. For Jeduthun. A Psalm of David.

¹ I said, "I will watch my ways
 and keep my tongue from sin;
 I will put a muzzle on my mouth
 while in the presence of the wicked."
² So I remained utterly silent,
 not even saying anything good.
 But my anguish increased;
 ³ my heart grew hot within me.
 While I meditated, the fire burned;
 then I spoke with my tongue:
⁴ "Show me, Lord, my life's end
 and the number of my days;
 let me know how fleeting my life is.
⁵ You have made my days a mere handbreadth;
 the span of my years is as nothing before you.
 Everyone is but a breath,
 even those who seem secure.
⁶ "Surely everyone goes around like a mere phantom;
 in vain they rush about, heaping up wealth
 without knowing whose it will finally be.
⁷ "But now, Lord, what do I look for?

My hope is in you.

⁸ Save me from all my transgressions;

 do not make me the scorn of fools.

⁹ I was silent; I would not open my mouth,

 for you are the one who has done this.

¹⁰ Remove your scourge from me;

 I am overcome by the blow of your hand.

¹¹ When you rebuke and discipline anyone for their sin,

 you consume their wealth like a moth—

 surely everyone is but a breath.

¹² "Hear my prayer, L\ORD,

 listen to my cry for help;

 do not be deaf to my weeping.

I dwell with you as a foreigner,

 a stranger, as all my ancestors were.

¹³ Look away from me, that I may enjoy life again

 before I depart and am no more."

 LEARN

Session 2 Video Teaching (16:00 min.)

Gather your group together to watch Lisa's second video teaching. You can use the outline and notes sections below to keep track of what you are learning.

Date:_____

You can stop trying to find what your purpose is for your life. Focusing on becoming God's woman = letting hard things transform us into our most useable self for the Kingdom of God.

Keep in mind:

- We can't produce our way into becoming God's woman.
- We can't bargain our way into becoming God's woman.
- We become God's woman by sitting with God through the uncomfortable process instead of running away.
- Stay with God, no matter what, and let Him do the transforming.

Notes

 DISCUSS

Group discussion is the most important part of the study. Take 20–45 minutes to process what you are learning with your group.

1. According to Lisa, you don't have to try to find your purpose in life. Every Christian's purpose is the same. Invite a group member to read Matthew 28:19–21 aloud. What do these verses say is every Christ-follower's purpose in life? Does this perspective change how you've always thought about purpose? In what way? Does realizing you no longer have to search for your purpose feel freeing?

2. We don't need to overcomplicate disciple-making, and it doesn't have to mean a radical life-change. No contribution to God's Kingdom is too small to mention here. How can you make disciples right where you are in your life? Be specific and don't be afraid of the most obvious answers (children, spouses, neighbors).

3. Many things can hinder our usability for God's Kingdom. For Saul it was insecurity, jealousy, and bitterness, to name a few. If you sense your usability is being limited, what are the things you need to face, and how can you actively let them go? Discuss what hinders you most and how you can contribute to removing your own hindrance(s).

4. Invite someone in your group to read Micah 6:7–8 aloud. Discuss what you hear God communicating in these verses. How do these verses apply to your daily life today?

5. Although we don't bring God burnt offerings or calves or olive oil, we do try to produce our way into usability. What are our modern-day "offerings" in our culture we use to bargain with God?

6. According to Lisa, the character-making process is about offering our hearts to God. In the past, what has helped you the most to offer your heart to God? What has been unhelpful?

7. Imagine you never run away from your problems, that facing them isn't scary or uncomfortable, and you've offered your heart to God with such devotion, you are more like Jesus. Imagine you've become God's woman, and you are maximizing your usability for God's Kingdom. Describe what your life would look like.

 PRAY

This prayer is for your group leader to pray over your group as a blessing. This is your opportunity to receive a blessing from the Lord before you pray for one another and take prayer requests. Prayer blessings are a biblical practice of loving others by calling on the Lord on their behalf.

> Lord, we praise You that You love us through the character-making process. Thank You for Your unfailing love. Help us offer You our hearts. We trust You to take care of our hearts with tenderness. We want to be women after Your own heart.
>
> In Jesus' name, amen.

Group Prayer Requests

You can use this space below to list your group members' prayer requests.

Pray as a group before you close your time together.

SESSION 2

Becoming God's Woman
Personal Study

 CONTEXT AND SETTING

Dealing with things we don't want to deal with can be difficult. (Someone say, amen!) It takes maturity and a spirit of willingness to even *look at* what is hard for us and how thus far has been our MO in how we've responded to it. Are you the showing-up with zealous enthusiasm kind? The wait-and-see-what'll happen kind? I'm the running-right at it kind who decided since running away didn't serve me anymore, I will take things head-on. None of the above approaches work in a vacuum, friend. In these lessons you're going to see another type of "runner," Saul. Saul's shortcomings and resistance to God's ways start right at the beginning of his reign. I'm wincing a little thinking about how Saul's missteps turn into a total departure from God's path . . . and how my own missteps land me at the same distance from God. We have so much to learn from his mistakes. We don't *have* to learn the hard way. Instead, here's an alternative: let's do the work of looking in the mirror without excuses and in full disclosure together this week. It is in doing this we take on something that could otherwise eventually become like with Saul, what overtakes us.

Read 1 Samuel 13:1–7.

1. Who does 1 Samuel 13:3 say defeated the Philistine garrison?

2. Based on 1 Samuel 13:4, who took the credit for the victory?

3. Based on 1 Samuel 13:6, why did Saul's army hide from the Philistines?

4. List the places Saul's army hid from the fight against the Philistines.

I know you've slept since then, but we've read about Saul hiding from his calling to be king in 1 Samuel 10:20–23, and now his men are following his example when they are afraid. Saul hid in baggage. And now his men are hiding in caves, holes, and in rocks, tombs, and cisterns—basically, anywhere they can fit.

Don't miss this crucial part of the story. When Saul ran away from God's call on his life, he gave permission for those he led to do the same. When we wrestle through the hard good, not only is our own usability at stake, but also the usability of those we will eventually lead. Courage to face our shortcomings now could mean generational change for those we love and minister to.

Next, Saul took matters into his own hands with an unlawful sacrifice to God. Apparently, Samuel had promised to join Saul in a certain amount of time, and after waiting seven days, Saul performed an unlawful sacrifice.

Read 1 Samuel 13:8–14.

5. Based on 1 Samuel 13:9, what sacrifices did Saul offer to God?

6. When Saul offered the sacrifices, whose place was he taking in temple worship?
 - God
 - Samuel, the priest

7. Why do you think Saul acted that way? Check all that apply.

 ☐ Saul was afraid.

 ☐ Saul grew impatient with God's timing.

 ☐ Saul was frustrated with Samuel.

 ☐ Saul feared his army would abandon him.

 ☐ Saul feared the Philistines would kill him.

8. Based on 1 Samuel 13:13–14, what is the consequence of Saul's sin?

This pierces my heart. I know the sting of consequences to my own sin, but this situation is next-level hard. Saul's kingship meant the stakes were higher, and his mistakes cost him the throne. I wonder how difficult it must have been to replay that moment in his life. Was he filled with regret? Frustration with himself? He was human, and in that moment, those feelings would have been the natural ones.

9. Can you relate to this moment in Saul's life? If so, how?

10. What lingering regrets do you have about a past or present situation in your life?

Read Romans 8:1–2.

11. What level of condemnation does Jesus have for your missteps?

12. Based on Romans 8:1–2, what have you been set free from?

You don't have to live in fear or regret or shame. Because of Jesus' life, death, and resurrection, we are free from that. He has secured for us all not a consequence-free life, but a condemnation-free life. It is a life without any hiding or running away.

I am praying the Holy Spirit is starting to make this truth a reality in your life and that regret is beginning to fade away even as you consider God's great love for you.

 ## INTO THE SCRIPTURES

If you've made a mess of a part of your life, even after fair warning from wise counselors, you are not alone. Not only do I understand, so would Saul. Right before Saul was installed as Israel's first king, Samuel gave a speech. In part, it was his retirement speech, and in part it was an effort to help God's people prepare to move from being ruled by judges to a king. I want you to look back on Samuel's words, now that you've read the way Saul's reign ended in a big mess. Notice how clear God was about how Saul should pursue leadership and how royally he rejected God's truth.

Read 1 Samuel 12:14–16.

1. What did God promise would happen to His people if they and their king obeyed Him?

2. What did God promise would happen to His people and their king if they did not obey Him?

Read 1 Samuel 12:24–25.

3. What two things did God want from His people and from their king?

4. What would be the consequence for disobedience?

God's love for His people or any of the kings never wavered. How could it? God is love, and He never changes. But God is so clear in 1 Samuel about how He wants to see His people respond to His love. He wants us to trust His promises and obey His instructions. God's clarity and intentionality to explain His expectations is more evidence that He loved and cared for His people. True to His word, His consequences were painful, but we see God's grace at work in spite of His people and their king's unfaithfulness. This is good news for us!

You and I are loved by God too. His love for you never changes. Ever. No matter how much either one of us blows it, His love remains the same. I want to encourage you to fill in the blanks below with specifics you and God already know about it and in the privacy between you, read it out loud to yourself as a reminder of His endless love for you. (Have tissues close by—you just might need them!)

In spite of _____, God loves me.

In spite of _____, God loves me.

In spite of _____, God loves me.

In spite of _____, God loves me.

In spite of _____, God loves me.

 ## PERSONAL APPLICATION

The monarchy was just barely established under Saul's leadership before he rejected God's ways and suffered the consequences. A short time had passed, and God was ready to anoint a new king, David. Keep in mind how tumultuous this would have been for the people living under Saul's rule. They would have heard about Saul's unlawful sacrifice, his disobedience to God, and his dismissal from the crown. I wonder if everyone was holding their breath, waiting to see how Saul would respond. Who would be the next king? How would Samuel help create a peaceful transfer of power?

Read 1 Samuel 16:1–13.

1. What did Samuel fear Saul would do if he found out God was sending him to Bethlehem to anoint a new king?

2. Based on 1 Samuel 16:7, how is God's assessment of people different from Samuel's own opinion?

3. How many of Jesse's sons were overlooked in the process?

4. Where was David, and what was he doing when Samuel sent for him?

5. How do you think David's brothers were processing his anointing as the future king?

Are you thinking what I'm thinking? This family and this nation are about to go through a lot of D-R-A-M-A. Saul was already riddled with unspoken insecurities that kept coming out in acts of defiance and fear, and now a new king was chosen, a very unlikely choice by all worldly standards. If you thought Saul's behavior had been bordering disastrous, he was suddenly about to fall straight into the downward cycle of jealousy and entitlement. Before we study the drama-filled change in leadership between Saul and David, I want you to sit with the uncomfortable and inevitable questions that the Holy Spirit might be stirring in your heart.

6. Where is there drama in your own life?

7. What's your role, if any, in the drama?

Read this statement out loud. Read it again. And maybe tomorrow read it again.

For today, I am not going to run. I am going to be honest and own the places that have hindered me thus far. I am going to let God use every part of who I am. His glory is my good.

RED THREAD REALITY

Watching Saul's life unravel is painful, isn't it? Saul typifies what happens when we resist the hard good work of God in our lives. Maybe nothing would have been as bad as the governing of the judges in the book of Judges, but as you have seen, Saul didn't kick off the monarchy with gusto, and soon we will see that although David exemplified a better king, he still was not perfect. At every turn of Saul and David's story, we are supposed to feel unsatisfied with the monarchy of Israel. Long-term, the monarchy of human kings is not a perfect solution to the problems humans face. You and I, just like the Israelites, need hope beyond human leadership.

Hannah, from the very first chapter of 1 Samuel, alludes to her need for hope in her beautiful prayer, which sets the tone for Saul's and David's reigns. In 1 Samuel 2, Hannah prays that God would "exalt the horn of his anointed" (v. 10). This horn is called the horn of salvation, and she was not talking about her son, Samuel, or any of the kings to follow him, like Saul or David. Hannah is referring to the Messiah, a King above all kings, and unlike all other kings. We are going to see this horn of salvation is a red thread throughout the Scriptures pointing us to Jesus. Hannah's hope in a future king who would never stumble or give up is what we could call a messianic hope. The messianic hope shows up multiple places in the Bible when the Bible authors talk about a "horn."

Notice the poetic reflections the psalmist makes on the covenant that God made with David's offspring.[3]

Psalm 89:24 says, "My faithful love will be with him, and through my name his horn will be exalted."

Psalm 132 also talks about this red thread reality as it "reflects on the promises Yahweh made to David and his royal line, especially how the throne of the Davidic heir would be established."[4]

Psalm 132:11, 17–18 says, "The LORD swore an oath to David, a sure oath he will not revoke: 'One of your own descendants I will place on your throne. . . . Here I will make a horn grow for David and set up a lamp for my anointed one. I will clothe his enemies with shame, but his head will be adorned with a radiant crown.'"

One of Jesus' closest friends and disciples wrote about his eyewitness account of Jesus' life, death, and resurrection in his gospel, the gospel of Luke. Luke's gospel starts with the prophetic song of a Jewish priest named Zechariah on the day his son, John the Baptist, was born. Notice how Zechariah's hope is also "centered in the future, coming 'David'"[5]

Luke 1:67–70 says, "His father Zechariah was filled with the Holy Spirit and prophesied: 'Praise be to the Lord, the God of Israel, because he has come to his people and redeemed them. He has raised up a horn of salvation for us in the house of his servant David (as he said through his holy prophets of long ago).'"

Hannah was right. Neither Samuel nor Saul nor David nor any good king can ultimately fix our problems. We need Jesus, the King who will bring redemption and reverse the effects of sin. If you've never experienced the saving grace of God through a personal relationship with Jesus, take a moment to connect with God through prayer. Here's an outline of something you could say to God if you are ready to start a relationship with him:

Dear God, I want to say out loud I believe Jesus is the Messiah I've always needed. He's the hope I've longed for. I believe Jesus died on the cross to save me from my sins and was raised from the dead to give me new life, abundant. I believe this with my whole heart. Be the Lord of my life moving forward.

Moving Past Your Past
Group Time

PRAY

As a group, pray aloud the Serenity Prayer by Reinhold Niebuhr.

> "God, grant me the serenity to accept the things I cannot change, courage to change the things I can,
>> and wisdom to know the difference."
>> In Jesus' name, amen.

SHARE

Take a few minutes to review and share your answers to these questions from the personal study lessons. No judgment here for anyone who didn't complete the lessons.

1. Based on Romans 8:1–2, what level of condemnation does Jesus have for your missteps? (page 34, session 2, Context and Setting, question 11)

2. Based on Romans 8:1–2, what have you been set free from? (page 35, session 2, Context and Setting, question 12)

READ

Invite someone to read aloud as everyone prepares their hearts for Lisa's teaching.

Psalm 30

Theme: A celebration of God's deliverance.

A Psalm, A song. For the dedication of the temple. Of David.

¹ I will exalt you, Lord,

for you lifted me out of the depths

and did not let my enemies gloat over me.

² Lord my God, I called to you for help,

and you healed me.

³ You, Lord, brought me up from the realm of the dead;

you spared me from going down to the pit.

⁴ Sing the praises of the Lord, you his faithful people;

praise his holy name.

⁵ For his anger lasts only a moment,

but his favor lasts a lifetime;

weeping may stay for the night,

but rejoicing comes in the morning.

⁶ When I felt secure, I said,

"I will never be shaken."

⁷ Lord, when you favored me,

you made my royal mountain stand firm;

but when you hid your face,

I was dismayed.

⁸ To you, Lord, I called;

to the Lord I cried for mercy:

⁹ "What is gained if I am silenced,

if I go down to the pit?

Will the dust praise you?

Will it proclaim your faithfulness?

[10] Hear, Lord, and be merciful to me;

Lord, be my help."

[11] You turned my wailing into dancing;

you removed my sackcloth and clothed me with joy,

[12] that my heart may sing your praises and not be silent.

Lord my God, I will praise you forever.

 # LEARN

Session 3 Video Teaching (16:00 min.)

Gather your group together to watch Lisa's third video teaching. You can use the outline and notes sections below to keep track of what you are learning.

Date:_____

When we've had a complicated past, we often feel as though we must do one of these two forms of denial:

- Disown our past—when we want nothing to do with our past.
- Decorate our past—when we want to remember our past better than it was.

The best way to be set free from the grips of a complicated past is to be completely honest about it, or to accept it.

How are these "what-if" questions keeping you from the freedom of acceptance?

- What if they . . .
- What if I . . .
- What if God . . .

If you trust and obey God, He will turn those defeating what-ifs into joy over what is.

Notes

 DISCUSS

Group discussion is the most important part of the study. Take 20–45 minutes to process what you are learning with your group.

1. According to Lisa, when we've had a complicated past we often try to deny it by doing one of two things, disowning it or decorating it. Which one most resonates with you, and why? What further consequence has your choice of denial resulted in?

2. Invite a group member to read aloud Matthew 26:36–46. Collaborate together to come up with several different ways Jesus accepted the hard good of His pending crucifixion.

3. How does Jesus' experience in the garden of Gethsemane shape your view of accepting something out of your control? How does Jesus' experience lead you to hope for what you might not be able to see?

4. Invite a group member to read aloud 1 Samuel 13:1–14. Collaborate together to come up with several different ways Saul lived in denial.

5. How does Saul's experience and consequence of offering the unlawful sacrifice shape your understanding of denial?

6. According to Lisa, three what-if statements get in our way of progress. Complete the one below that most resonates with you.

What if they . . .

What if I . . .

What if God . . .

7. According to Lisa, what-if statements keep us stuck, but the words *what now?* set us free. If you took the words *what now?* seriously, how would your life look differently?

PRAY

This prayer is for your group leader to pray over your group as a blessing. This is your opportunity to receive a blessing from the Lord before you pray for one another and take prayer requests. Prayer blessings are a biblical practice of loving others by calling on the Lord on their behalf.

> Lord, You know what thing didn't work out for each of us. But we don't want to be stuck asking You what-if questions. Set us free to embrace what-is in a healthy way. Give us more joy as we trust You are bringing the hard good to our lives.
>
> In Jesus' name, amen.

Group Prayer Requests

You can use this space below to list your group members' prayer requests.

Pray as a group before you close your time together.

Moving Past Your Past
Personal Study

 ## CONTEXT AND SETTING

Maybe you've read the meme that says, "Comparison is the thief of joy," on social media and given it a big thumbs-up or heart emoji. It's so true, isn't it? When we compare ourselves to each other, the Enemy plays on our insecurities and turns us against ourselves and each other.

When you are studying the Bible, however, comparison is actually a really helpful literary tool of discovery. We will see that in action today. We've spent a couple of weeks now talking about Saul's checkered past as Israel's first king, and we've even dug deep together to see how we often make the same choices.

Bottom line: Don't be like Saul. Bailing on God and our calling is no way to live.

But before we get too judgmental, we have to be honest and admit it is the tendency we all face, especially when we avoid working on places where we need spiritual growth. As we go searching for more definitive examples of how to shift our Saul-likeness to a godliness, we turn our attention to king David's humble beginnings. It becomes quickly apparent how the author of 1 Samuel intends for you and me to start comparing these two men. By comparing their lives and their leadership, we will discover the best ways to stay with God when things get hard.

First, let's read about David's battle with Goliath and see the setting God provides to create comparison.

Read 1 Samuel 17:1–11.

1. List everything you learn about the Philistines' champion warrior, Goliath.

2. Based on 1 Samuel 17: 8–10, what challenge did Goliath issue to Saul and his army?

3. How did all of Israel and Saul respond to this threat?

4. Based on what you've learned so far about Saul, how does his fear correspond with his responses to other challenges in his life?

5. What brings you the most fear in your own life right now? What is your metaphorical Goliath?

Fear is such a bully. I see you, scared and doing it, anyway. I see you pushing through the hesitations and reaching out for help. I see you working through your Bible study and keeping in touch with your small groups. Keep at it! You don't have to live in fear like Saul. The courage of David is available to you through the Holy Spirit's power. Stay with God through this. He's got you. Notice with me the challenges we face when we choose to be brave.

Read 1 Samuel 17:12–22.

6. Some of David's brothers were fighting in battle. What was David's role in his family and in the battle at this point?

7. According to 1 Samuel 17:16, how long did David do this?

8. What did David's father want him to do once he reached his brothers on the battlefield?

9. What did David do with the food he was delivering to his brothers in 1 Samuel 17:22?

Unlike Saul in 1 Samuel 10:22, running from his calling to hide in the baggage, David left his things with the baggage keepers and ran *to* the frontlines of the battle to check on his brothers. What a contrast. We should get the sense that our obedience to God and faith in his promises can make or break the battles we are fighting.

David left his past as a shepherd and began acting like the warrior-king he grew into during his own reign as king. His humble beginnings and brave start mattered. And it matters for you too. If you feel humbled by a fresh start or fearful about the giants in your life, hang tight. God is going to provide everything you need to carry on in faithfulness as you hold onto Him. Let's look together and see what victory, true victory, looks like with God's help.

But first, what is the number one difference you notice between Saul and David when each was appointed and anointed to be king?

Saul's response:

David's response:

INTO THE SCRIPTURES

David didn't let his past as a shepherd limit his faith in God's ability to use him in the future, and I pray we will follow his example. No matter what you might lack right now, God has promised a bright future for you (Jeremiah 29:11), and He is fully capable of helping you maximize your gifts and live out your calling. But you must be willing to move past a difficult past in order to be delivered from it. Notice how God delivered David from his past. He can do the same for you.

Read 1 Samuel 17:23–37.

1. What did David hear from Goliath?

2. How did the men of Israel respond to Goliath's threats?

3. How did David's response differ from the other Israelites'?

4. Why do you think Eliab responded to David the way he did?

I have to laugh at Eliab's response to David. This sounds like classic sibling rivalry to me. Had I been in Eliab's shoes, I, too, would have been ticked at my younger brother. Especially since Eliab had been stationed in the battle for forty days while David rested safely in his own bed and spent his days peacefully taking care of sheep. I imagine my response to David's bravery would have been a big eye roll and a loud, long sigh. Worn down by battle and the fear of giants, Eliab's perspective was skewed.

What's your perspective on the battlefield? Are you quick to judge? Temperamental? Annoyed at someone else's bravery? These are sure signs you are trusting in yourself for victory. Facing a giant, your strength might seem puny, but with God all things

are possible. Not just for you but for everyone. When we find ourselves flustered or even resentful of someone else's faith in God's deliverance, we know we've missed the lesson in the hard good.

5. Write out David's words to King Saul (v. 32).

6. Write out Saul's response to David (v. 33).

7. If you feel you lack something in your life right now, would it be any of these? Check all that apply.

□ Experience

□ Education

□ Opportunity

□ Courage

□ All of the above

8. List all the reasons David believed he would be successful in defeating Goliath.

If you and I are willing to be used by God, he *will* use us for His glory and for the good of others. God will deliver you from insecurities and fear. From a difficult past and scary present. God will deliver you into victorious living. Nothing can stand against God's power, and He's made it available to us through His Holy Spirit. Stand your ground. Stay brave. It matters, and it's forming your character to be more like Jesus.

 ## PERSONAL APPLICATION

I used to think David went into this battle with Goliath unarmed. But actually, he was suited up with faith in God and the resources familiar to him in everyday life. When David's gear didn't fit him, he opted to believe God's victory was secure no matter what he had in his hand to fight with. As you will see in the next passage, Saul tried to clothe David with his armor, but David opted to go without armor and fight Goliath with the resources he was most effective using: a staff, smooth stones, a sling, and his shepherd's pouch.

Read 1 Samuel 17:38–50.

1. What does David's choice for battle attire reveal about his character and his faith in God?

2. Goliath offered David some smack talk on the battlefield, and David's response reveals his heart for God. What did David say to Goliath about his readiness to fight?

3. Based on 1 Samuel 17:47, who did David believe determined the outcome of the battle?

4. According to 1 Samuel 17:50, David prevailed "without a sword in his hand." Why is this detail so significant to this story and to David's future as king?

When you are facing a giant, your faith has to be in God. David's stand against Goliath was not just bold and brave; it was an act of faith. The same God that took care of David while he was a shepherd would carry him through his fight with Goliath. When we take time to consider all the ways God has seen us through our trials in life, our faith grows and helps us get past just seeing the hard and moving to where it becomes the hard good.

5. In what ways has God rescued you in the past?

Read Ephesians 6:10–17.

6. Which part of God's armor do you need most and why?

Put pen to paper and declare how you will move past your past and close the distance between your life now and the life God has in store for you.

I will no longer _____.

I will _____.

Because God has _____.

And God is _____.

 ## RED THREAD REALITY

King David's story in the Old Testament is crucial to God's story of redemption. Not only does he become Israel's greatest warrior-king, his reign was a bridge to the New Testament. When God promised that David's reign would never end, he meant that Jesus would eventually come from the line of David and rule God's Kingdom forever.

Did you notice the theme of shepherding present in David's story? He started as a shepherd in the field tending to sheep and became a shepherd to God's people as king. Although David was a man after God's own heart and was used greatly to rule with integrity and justice, he wasn't perfect. Some of the ways he misused his power resulted in abuse, murder, and war. Even still, David was the best Israel had in terms of a great king. That leaves us, as the readers of this incredible true-life story, wondering how God will redeem His plans for His people to bless all nations if the best of the kings isn't good enough.

Enter Jesus. The Good Shepherd and the King of all kings.

One of Jesus' closest friends and disciples was a man named John. In John's gospel, he quoted Jesus talking about Himself, revealing He is the promised Shepherd we've all been waiting for.

John 10:11 says, "I am the good shepherd. The good shepherd lays down his life for the sheep."

Even David knew he needed the Lord to shepherd him.

In Psalm 23:1 David wrote, "The LORD is my shepherd, I lack nothing."

When the author of Hebrews closed his book, he reminded Christ-followers to experience God's peace the way a sheep would experience a shepherd's care and protection.

Hebrews 13:20–21 says, "Now may the God of peace, who through the blood of the eternal covenant brought back from the dead our Lord Jesus, that great Shepherd of the sheep, equip you with everything good for doing his will, and may he work in us what is pleasing to him, through Jesus Christ, to whom be glory for ever and ever. Amen."

SESSION 4

Overcoming Internal Struggles
Group Time

PRAY

Pray aloud as a group.

> Lord, we want to overcome jealousy, bitterness, and these unspoken struggles in our lives. Give us the capacity to cheer for others when they receive what we want. Show us how to live more like Christ. Help us.
>
> In Jesus' name, amen.

SHARE

Take a few minutes to review and share your answers to these questions from the personal study lessons. No judgment here for anyone who didn't complete the lessons.

1. What brings you the most fear in your own life right now? What is your metaphorical Goliath? (page 48, session 3, Context and Setting, question 5)

2. Based on Ephesians 6:10–17, what part of God's armor do you need most right now? (page 55, session 3, Personal Application, question 6)

 READ

Invite someone to read aloud as everyone prepares their hearts for Lisa's teaching.

Psalm 32

Theme: Forgiveness brings true joy.

A Psalm of David.

Of David. A maskil.

> ¹ Blessed is the one
>> whose transgressions are forgiven,
>> whose sins are covered.
> ² Blessed is the one
>> whose sin the Lᴏʀᴅ does not count against them
>> and in whose spirit is no deceit.
> ³ When I kept silent,
>> my bones wasted away
>> through my groaning all day long.
> ⁴ For day and night
>> your hand was heavy on me;
> my strength was sapped
>> as in the heat of summer.
> ⁵ Then I acknowledged my sin to you
>> and did not cover up my iniquity.
> I said, "I will confess
>> my transgressions to the Lᴏʀᴅ."
> And you forgave
>> the guilt of my sin.

⁶ Therefore let all the faithful pray to you
 while you may be found;
surely the rising of the mighty waters
 will not reach them.
⁷ You are my hiding place;
 you will protect me from trouble
 and surround me with songs of deliverance.
⁸ I will instruct you and teach you in the way you should go;
 I will counsel you with my loving eye on you.
⁹ Do not be like the horse or the mule,
 which have no understanding
but must be controlled by bit and bridle
 or they will not come to you.
¹⁰ Many are the woes of the wicked,
 but the Lord's unfailing love
 surrounds the one who trusts in him.
¹¹ Rejoice in the Lord and be glad, you righteous;
 sing, all you who are upright in heart!

 # LEARN

Session 4 Video Teaching (18:30 min.)

Gather your group together to watch Lisa's fourth video teaching. You can use the outline and notes section below to keep track of what you are learning.

Date:_____

If you are struggling with jealousy, bitterness, insecurity, or rejection you might be:
- Questioning your gifts and calling.
- Tempted to quit.
- Feeling resentful of others.
- Feeling mad at God.

Let God turn your tough internal struggles around to turn you into the healthy person you were created to be and the best supporter of other people.

Where is your heart? Half-hearted, whole-hearted, no-hearted

How to overcome internal struggle:
- Be honest with God and come clean with others.
- Work on it—don't let it just sit.
- Do the hard thing.
- Defy Satan's hold on you.

Notes

DISCUSS

Group discussion is the most important part of the study. Take 20–45 minutes to process what you are learning with your group.

1. When you're struggling with jealousy/envy over what someone else has, bitterness from rejection/hurt, anger, fear, shame, or insecurity, which of these describes how you respond? Check all that apply. Briefly discuss how your go-to response is working for you.

☐ I question my gifts and calling.

☐ I think about quitting.

☐ I become even more resentful.

☐ I pull away from relationships.

☐ I think negative thoughts much of the time.

☐ I get mad at God.

☐ I feel entitled to a different life.

2. According to Lisa, one of the best ways to overcome jealousy is by cheering for others when they get something you want. What are some of the things you want in life that you don't have or have yet? Think of someone you can name (to yourself)

who has what you want. Share with the group how you can cheer this person on (without naming him/her).

3. If you were able to cheer others on, describe how your life might be different?

4. Share with your group what hindrance you want God to work on in you—what can you let go of (behavior, emotion, reactions, hurt, etc.)? Perhaps the reason you've never been able to gain victory over your struggle has something to do with trying on your own. We do not exist in silos in the Kingdom—we are sisters by God. Let your group be the group God designed it to be. Give your greatest hindrance to the group and let them help take it from you.

5. Have you allowed God to take the things that are tough for you and use them to become beautiful places of triumph and healing in your life? Share in what ways and what was the outcome.

6. Saul had no heart for God . . . David was all heart . . . and Solomon had a half-heart. Discuss each 'heart' as a group. What does a person of each 'heart' look like in daily life? Do you know someone personally in each category? Which category do you find yourself in?

 ## PRAY

This prayer is for your group leader to pray over your group as a blessing. This is your opportunity to receive a blessing from the Lord before you pray for one another and take prayer requests. Prayer blessings are a biblical practice of loving others by calling on the Lord on their behalf.

> Lord, Your kindness is what leads us to repentance. Thank You for Your tender and gentle care. We're ready for You to transform our struggles into joy. Use us this week to encourage people around us when we see You are at work in and through them. Change us into cheerleaders for others.
> In Jesus' name, amen.

Group Prayer Requests

You can use this space below to list your group members' prayer requests.

Pray as a group before you close your time together.

Overcoming Internal Struggles
Personal Study

 CONTEXT AND SETTING

Something that I think we often miss when it comes to spiritual transformation is this: the understanding that what God wants *from* us He wants *for* us. We often think of change and growth in response to our obedience to the Lord, and certainly, it is important to change and grow for that reason, alone. But we forget that it is out of the depth of love the Lord has for His kids He gives us instructions and parameters. He created a life of abundance that follows a pure-hearted, pure-minded path, and He knows that straying from that for us will only bring us pain.

I'm taking a bit of a liberty here, but when it comes to your internal struggles, imagine Jesus saying to you, "you can stay _____ (jealous, bitter, insecure, angry, etc.), but I don't want you to settle for that because I have more for you." Jealousy, for instance, ruins relationships and forms bitter soil inside of hearts—Saul shows us that.

In all of his internal struggles, self-preservation in the moment and unwillingness to do the hard good thing resulted in Saul having underdeveloped character and someone who never truly became "God's man." It has a similar effect on us. When natural feelings of jealousy toward David arose within Saul's heart, he gave in to them rather than giving them to God, who could help him deal with them right away. This was never God's best for him, as it was to his detriment.

Read 1 Samuel 18:6–18.

1. What about the women's songs made Saul jealous of David?

2. Saul's jealousy turned dangerous. How did he try and harm David?

3. Have you ever experienced "dangerous jealousy" or bitterness that got out-of-control? Describe your frame of mind. Now, think about how much of your focus was on God in that moment. What would have been different had your focus been on Him?

You might be familiar with the phrase, "Comparison kills." Sadly, in Saul's life, this saying was not just a metaphor. His anger consumed him and almost took David's life. Jealousy is dangerous. It can make us miserable, and in worst cases, compel us to act sinfully toward others.

4. Saul became suspicious and fearful of David for the same reason David was successful in all his undertakings. Based on 1 Samuel 18:12–14, what was the reason?

5. While Saul was stewing with envy, his people adored David. How do you think his people's response intensified his jealousy?

6. If you are struggling with jealousy, what are the contributing factors to your jealousy? What are you hyper-focused on when you are overcome with jealousy?

Read James 3:14–16.

7. What does James say about envy?

8. If you need to be more honest about your internal struggle, whether its jealousy, bitterness, regret, whatever, write out a prayer asking God to help you do just that.

INTO THE SCRIPTURES

Unwarranted jealous thoughts barrage all of us at times, making it difficult for us to think clearly, rationally, and positively. That's real life. It's what we do next that determines who we become. When we allow God to use the hard moment, we *let* our soul free to receive the good our envious heart sought to begin with.

Read 1 Samuel 18:20–30.

1. Why did Saul want his daughter, Michal, to marry David?

2. How did this plan backfire on Saul?

3. What does Saul's matchmaking teach us about the dangers of jealousy?

4. We have to consider who Saul might have become had he handed over his jealous feelings for David to God rather than continuing to let them accompany him throughout his entire journey. He was a capable, anointed, and appointed leader who did things for God, but what more could he have done? And how much more does want God to do with us, but our jealousy for other people is hindering it?

Read 1 Samuel 19:1.

5. What was the end result of Saul's jealousy?

Jealousy can cause us to withhold celebration for, resent, and even scheme against our friends and loved ones, especially when they get something we want. We want to be able to say "gotcha" as we one-up them, want them to go without or at least feel the way we do by not experiencing complete success. It's hard to admit, but it's true. Sometimes our struggle with contentment has a dark side. The good news is, Jesus can help us, by the power of the Holy Spirit, to overcome.

Sadly, Saul's jealousy turned murderous. He tried several times to kill David. He hunted his own son-in-law with relentless attempts to take David's life. At that point in Saul's story we feel so far away from that coronation moment when Samuel anointed Saul's head for the crown. Saul's example should be a wake-up call for us.

If you feel like you've spun out of control, take this time to quiet yourself before God and share your struggle with Him. He won't shame you. He wants to free you from any sin struggle, and He can. Acknowledgement (often even to ourselves) is a powerful first step, followed by contrition (showing sorrow over the sin), confession, and repentance.

Friend, I know this part of the study is hard emotional work. Pause for a few minutes, if you need to. Take a deep breath. I'm with you in this, all the way. But I promise: you're doing a great job sticking with it. And we are getting somewhere. The next part will feel like a relief. David is going to show us what it looks like to de-escalate jealousy and avoid its entrapments.

 ## PERSONAL APPLICATION

Maybe the reason you've not wanted to look at your internal struggles over something like jealousy before is because you've felt inside Christian circles that you were a terrible

person if you ever admitted these very human feelings. After all, envy is not pretty, and women don't like to associate with ugly things. And it's true: the subtle shaming that takes place over real, flesh jealous feelings, especially among Christian women, is rarely addressed. We are not supposed to feel *those ways*. Often, instead of talking through them, we are talked out of them. Temporarily, of course, since the root of the feelings don't get dealt with. Eventually they crop back up.

While I don't propose we normalize jealousy in the sense we accept it from ourselves (I would hope by this point in the session you know how I feel about its detriment to our souls), I do want us to tackle this in a better way than denial or shaming. Neither of those things help us deal with our struggle—a struggle I have not been immune to myself.

Read 1 Samuel 24:1–22.

1. David came really close to killing Saul, close enough to corner him in a cave and cut off a piece of Saul's clothing. Why couldn't David go through with it?

2. Based on 1 Samuel 24:10–11, how did David appeal to Saul to put a stop to this vicious cycle?

3. Who did David leave vengeance to?

4. Based on 1 Samuel 24:17, what did Saul realize about David?

5. Based on 1 Samuel 24:20, what did Saul realize about David's reign?

6. What did Saul ask of David, and how did David respond?

7. Based on David's example, what do you learn about having a heart after God?

What we really need (and want, I believe) is to know what to do with our natural human reactions/internal struggles. We want to live free of jealousy and to support one another, but many of us have not been told how to exchange them for a better way. We need to be honest about it with each other. But it takes a lot of maturity to have that conversation. Not dealing with it doesn't help any of us grow or get healthy. Jealousy blocks our ability to cheer for other people, but it also blocks us from being in a position to be successful ourselves.

RED THREAD REALITY

The Scriptures give us the encouragement we need to be honest with ourselves and with our faith community. Here's what you need to remember. You may have gotten yourself into a tangled web of human emotion, but God's mercy can undo it all. The apostle Paul's letter to Titus tells us as much.

Read Titus 3:3–7 below:

> At one time we too were foolish, disobedient, deceived and enslaved by all kinds of passions and pleasures. We lived in malice and envy, being hated and hating one another. But when the kindness and love of God our Savior appeared, he saved us, not because of righteous things we had done, but because of his mercy. He saved us through the washing of rebirth and renewal by the Holy Spirit, whom he poured out on us generously through Jesus Christ our Savior, so that, having been justified by his grace, we might become heirs having the hope of eternal life.

Paul describes life before Christ this way:
- Foolish
- Disobedient
- Enslaved to passions and pleasures
- Living in malice and envy
- Being hated and hating one another

Read Galatians 1:10–17.

Write out some of the ways Paul described his life both before and after Christ:

Write your own description of life after Christ, bullet points or a brief statement.

What experiences or personal perspective of your own changes the trajectory of your life and specifically your struggle with jealousy?

Let God take it all and transform it.

Do that. Do it now, in this moment, let God take the struggles and transform them into something new.

SESSION 5

Showing Up vs. Shutting Down
Group Time

PRAY

Pray aloud as a group.

Lord, when things get hard in life, we want to shut down. We know You have a different way of life available to us, a posture of staying present instead of shutting down. As we learn more about You, show us how. Give us what we need to stay with You when we get uncomfortable.

In Jesus' name, amen.

SHARE

Take a few minutes to review and share your answers to these questions from the personal study lessons. No judgment here for anyone who didn't complete the lessons.

1. What does James 3:14–16 say about envy? (page 67, session 4, Context and Setting, question 7)

2. If you are struggling with jealousy, what are some of the contributing factors to your feelings? (page 67, session 4, Context and Setting, question 6)

 READ

Invite someone to read aloud as everyone prepares their hearts for Lisa's teaching.

Psalm 17

Theme: A plea for justice in the face of false accusations and persecution.

A prayer of David, written while he was being persecuted by Saul.

A prayer of David.
> ¹ Hear me, Lord; my plea is just;
> listen to my cry.
> Hear my prayer—
> it does not rise from deceitful lips.
> ² Let my vindication come from you;

 may your eyes see what is right.
³ Though you probe my heart,

 though you examine me at night and test me,
you will find that I have planned no evil;

 my mouth has not transgressed.
⁴ Though people tried to bribe me,

 I have kept myself from the ways of the violent

 through what your lips have commanded.
⁵ My steps have held to your paths;

 my feet have not stumbled.
⁶ I call on you, my God, for you will answer me;

 turn your ear to me and hear my prayer.
⁷ Show me the wonders of your great love,

 you who save by your right hand

 those who take refuge in you from their foes.
⁸ Keep me as the apple of your eye;

 hide me in the shadow of your wings
⁹ from the wicked who are out to destroy me,

 from my mortal enemies who surround me.
¹⁰ They close up their callous hearts,

 and their mouths speak with arrogance.
¹¹ They have tracked me down, they now surround me,

 with eyes alert, to throw me to the ground.
¹² They are like a lion hungry for prey,

 like a fierce lion crouching in cover.
¹³ Rise up, Lord, confront them, bring them down;

 with your sword rescue me from the wicked.
¹⁴ By your hand save me from such people, Lord,

 from those of this world whose reward is in this life.
May what you have stored up for the wicked fill their bellies;

 may their children gorge themselves on it,

 and may there be leftovers for their little ones.
¹⁵ As for me, I will be vindicated and will see your face;

 when I awake, I will be satisfied with seeing your likeness.

LEARN

Session 5 Video Teaching (18:00 min.)

Gather your group together to watch Lisa's fifth video teaching. You can use the outline and notes sections below to keep track of what you are learning.

Date:_____

We usually shut down instead of staying present because:
- We feel insecure.
- God doesn't do what we want Him to.
- Our emotions are bossing us.

> **Faith is where we get the strength to show up and trust, show up and obey, show up and move on, even when we want to shut down.**

Important aspects of showing up for your own life, with God's help:
- Don't ignore your body.
- Don't ignore your mind.
- Don't ignore your soul.

Notes

DISCUSS

Group discussion is the most important part of the study. Take 20–45 minutes to process what you are learning with your group.

1. In what positive ways are you showing up for your life right now?

2. What emotion is threatening to overtake you?

3. What are your most likely reactions when you want to shut down? Why? Check all that apply.

 ☐ Give people the silent treatment

 ☐ Deflect and put focus on something of less consequence

 ☐ Run away from pain

 ☐ Lash out in anger (at anything or anyone)

 ☐ Deny and hide

4. How does your body respond when you shut down? Check all that apply.

☐ Racing pulse

☐ Shaky voice

☐ Short with our answers

☐ Tears well up

☐ Sweaty palms

☐ Exhaustion

☐ Shortness of breath

5. According to Lisa, one of the reasons we stay shut down when we want to be present is the fear of being vulnerable. Why do you think being vulnerable is such a challenge for many of us? What is your greatest fear in being vulnerable? Be honest here; if we can't first be honest about our struggle, we can't be transformed.

6. Which effects of shutting down have you experienced before? Check all that apply and discuss the ramifications in other areas of your life.

☐ Broken relationships

☐ Resentment

☐ Isolation

☐ Ingratitude

☐ Inability to see the world positively

☐ Bitterness

☐ Distance from God

☐ Inability to produce great work

☐ Emotional growth stunted

☐ Unrealized potential/influence

☐ Apathy toward physical health

7. Which effects of showing up have you experienced before? Check all that apply and discuss the value each has brought to your life.

☐ Added strength and confidence

☐ New perspective on hard things

☐ More open and loving

☐ True joy over being the bigger/better person

☐ An attitude of gratitude

☐ Less fear that something hard will take you down

☐ Emotional control instead of emotions controlling you

☐ God-honoring behavior

☐ Renewed care for your personal health and well being

☐ More available for God to use your life

PRAY

This prayer is for your group leader to pray over your group as a blessing. This is your opportunity to receive a blessing from the Lord before you pray for one another and take prayer requests. Prayer blessings are a biblical practice of loving others by calling on the Lord on their behalf.

> Lord, I bless these women with your power to stay with You instead of backing away and shutting down. Provide to each of them the strength to maneuver through difficult emotions. Give each of them discernment and courage to trust You more.
>
> In Jesus' name, amen.

Group Prayer Requests
You can use this space below to list your group members' prayer requests.

Pray as a group before you close your time together.

Showing Up vs. Shutting Down
Personal Study

 ## CONTEXT AND SETTING

If there's one thing hard things have taught me, it's that while all of us go through them, we all handle them quite differently. Consider the difference between the way David and Saul handled things. Both were anointed and appointed by God for kingship. Both were imperfect. But because of the way they responded to the tendencies of the flesh, they were used very differently. Both accomplished some things. But only David yielded his will, and as a result, only David ever truly became God's man.

At one point, David knew he was going to be king, but Saul still held the position. No doubt, under Saul's poor leadership, David must have felt he could do the job better. No question, he wanted Saul dethroned. But he respected God too much to interfere. We see this deference to God by David (despite undoubtedly real human feelings) throughout the book of 1 Samuel.

Read 1 Samuel 26:1–12.

1. What could David have done to stop Saul's murder attempts?

2. What did David choose to do?

3. Why did David resist revenge?

David could have easily put an end to Saul's murderous threats by taking matters into his own hands, quite literally. Instead, he chose to recite to himself and to Abishai the truth: the Lord forbids harming His anointed king. God said not to mess with Saul, and David obeyed. Staying true to God's command must have been extremely difficult. Sometimes following God is hard for me in my everyday run-of-the-mill challenges when my life is nowhere near being on the line. Keep in mind, Saul's pursuit of David is not an isolated incident. The story you just read is the second time Saul was hunting David for the purpose of killing him.

4. Showing up is ultimately a matter of spiritual obedience when all else doesn't make sense—it certainly was for David. Continuing to believe God is with you and in "it" when life looks grim and is hard. Can you name a time when you've had to show up in obedience and felt unsure but showed up anyway? Can you define what kept you from running or turning away?

No doubt, David's self-control based on God's Word helped him later when he ruled over a divided kingdom. Stick with me here, and let's read together the circumstances surrounding David's anointing as the new king of Israel.

Read 2 Samuel 2:1–11.

5. Based on 2 Samuel 2:5, why did David applaud and bless the men of Jabesh Gilead?

 If this isn't staying present instead of shutting down, I don't know what is. Even after Saul's murder attempts and years of jealousy toward David, David stayed the course with God. In Saul's death we don't find David rejoicing over anything, *except* for the fact that Saul's body was honored after his death. David seems to give honor and deference at a time when the natural inclination would be to wash his hands of all the family drama, and even be happy that the man who has caused him anguish is finally gone.

Read 2 Samuel 2:6–7.

6. Can you relate to David's obedience in staying faithful to God no matter what?

7. What was David's focus in this turn of events and how can his choice of focus help direct your own focus to show up or shut down? (Remember—David was not a perfect man, though we sometimes elevate him because of his often godly behavior. He was merely a man who was not much different than Saul in many ways—he sinned, was selfish, struggled with his flesh and human doubts—so what do you think pulled David toward God rather than further away in the moment it mattered most? Do you see where the possibility in acting differently (like David) than your human nature (like Saul) would lead you—and what would make that difference?

INTO THE SCRIPTURE

A testament to staying present instead of shutting down, David is one of our go-to's for how-to's, and for good reason. Not only did he wait fifteen years to be inaugurated as king, but he waited well. To me, that's harder. I can wait if I absolutely have to, but I can't guarantee I'll be in a good mood. There's nothing remarkable about going through something you had no say in. There's also nothing special about waiting and becoming bitter or mad. A lot of us do that.

What takes this up several notches and sets someone like David apart is that whenever he was stuck living in the in-between, *he wrote songs.* From the time he was promised he would be king to when he was finally enthroned, he composed. All throughout a long, risky season of being pursued by his enemies until he no longer had to live on the run. I know what kind of mental state I would be in if I had to wait that long for God to make good on something he'd promised me—not great. But David passed his time writing lyrics of praise—and often of angst. This is remarkable. To do that, you've got to have the real stuff.

Read Psalm 57, a psalm written when David fled Saul into a cave.

1. According to Psalm 57:1–2, what was David afraid of? What comforted David?

2. List every way in which David's pursuers were seeking to harm him.

3. According to Psalm 57:7, what emotion did David feel in spite of this danger?

As a creative myself, I know that often a slight hitch in my day alters my ability to string even one sentence together, let alone paint an entire brilliant, poetic narrative like any one of David's psalms. David never faked being fine. He lived in constant tension and with a desperate desire to get from A to B. Yet despite enduring long uphill battles and waiting for promises that never seemed they'd come to pass, he remained in a good place with God. Generational healing to our souls has come through his words because of it.

 PERSONAL APPLICATION

When God makes us wait, it's because He wants to save us from something, give us something better, or form in us something we need. For me to write this, it rolls right off my fingertips. For you to highlight it probably feels right too. But living it is a whole different hard story.

Read 2 Samuel 22.

1. In 2 Samuel 22 David described God in several different ways. List your top five favorite ways David talks about God and write out the verse reference next to your favorites.

Attribute of God	Verse

2. According to 2 Samuel 22:21–25, why and how (in what ways) did David experience the benefits of God's covenant with him?

Nearly every mistake I've ever made in any scenario in which I didn't want to wait on God has been marked by these behaviors: compromise, backsliding, and taking matters into my own hands. Maybe you can relate? I've tried it when I've wanted something to happen with my career, and God was taking too long to deliver. When I've wanted something to happen with our housing. When I've wanted to hurry along relationship potential. Without fail, my desire to push God faster has resulted in messy complications, and I've visited heartache upon my own soul.

3. What matters are you taking into your own hands?

4. What would it look like to release those into God's hands and trust His timing and promises?

RED THREAD REALITY

Although David was far from perfect, his military conquests and heart for God set him apart from all the other kings of Israel. In his early life and the beginning of his reign, he stood out, in comparison to Saul, as an example of what it means to rule with righteousness, to obey God even when it is hard, and to keep the faith in the midst of life-threatening challenges. We can't underestimate his fame and renown during this kingship and even now. I would dare say, he is the most well-known king of Israel and the closest we have to a "good" king who protects his people like a good shepherd.

That's why, when Matthew summarized all the historical moments he saw with his own eyes in his gospel account, the book of Matthew, he emphasized that Jesus is the "Son of David." Everyone knew a messiah had been promised to the Jews, and it would be a savior, a deliverer who would come from the line of David and rule forever as promised in the books of 1 and 2 Samuel. When Jesus arrived on the scene, teaching with the authority of God rather than just a scribe or Pharisee, and healing people who had been suffering with physical, emotional, and spiritual oppression, everyone privy to Jesus' teaching and healing ministry was thrown off guard. Who was this guy? He claimed to be God, but he was "just" a carpenter from a no-nothing town called Nazareth.

In his gospel, Matthew led with the very first verse what he was going to try and show is the truth about Jesus: "This is the genealogy of Jesus the Messiah the son of David." Did you catch that? Matthew didn't even finish the first sentence of his gospel without introducing us to Jesus as the "son of David." Matthew was relentless with this term throughout his eyewitness account of Jesus' life, death, and resurrection. This is not an exhaustive list, but check out this pattern in Matthew:

- While Jesus was traveling from place-to-place healing people, he healed two blind men who called out to him in desperation, "Have mercy on us, Son of David!" (Matt. 9:27).
- When Jesus healed a demon-possessed man who was blind and unable to speak, the crowds responded asking, "Could this be the Son of David?" (Matt. 12:23).

- When a Canaanite woman rushed to Jesus to see if he would heal her severely tormented, demon-possessed daughter, she cried out, "Lord, Son of David, have mercy on me!" (Matt. 15:22).
- When two blind men outside of Jericho sitting by the road heard Jesus passing by they cried out, "Lord, have mercy on us, Son of David!" When the crowds tried to shut them up, they cried out again even louder this time, "Lord, Son of David, have mercy on us!" (Matt. 20:30-31).
- During Jesus' triumphal entry into Jerusalem, just days before his crucifixion, people lined the streets and started waving palm branches to welcome what they believed to be the Messiah, and here's what they said, "Hosanna to the Son of David!" (Matt. 21:9).

To anyone impressed with parts of David's reign as king, to anyone marveling at his faithfulness and righteousness and compassion, Matthew is determined for you to see that Jesus is the Son of David, the greater king. The greatest of all kings. In Matthew, each time the sick cried out to Jesus and referred to Him as Son of David, they asked him to be merciful. This is the mark of the God-King, Jesus. He is merciful. His compassion for you will never fail.

SESSION 6

Embracing the Hard Good
Group Time

PRAY

Pray aloud as a group.

> Lord, help us walk the hard road of transformation with You and experience the results in holy payoff. Even while we are changing to be more like Jesus, You remain the same. Thank You for being the God we can always count on.
>
> In Jesus' name, amen.

SHARE

Take a few minutes to review and share your answers to these questions from the personal study lessons. No judgment here for anyone who didn't complete the lessons.

1. What matters are you taking into your own hands? (page 90, session 5, Personal Application, question 3)

2. What would it look like to release those into God's hands and trust His timing and process? (page 90, session 5, Personal Application, question 4)

 READ

Invite someone to read aloud as everyone prepares their hearts for Lisa's teaching.

Psalm 63

Theme: A desire for God's presence, provision, and protection.

A Psalm of David, When he was in the Desert of Judah.

¹ You, God, are my God,
 earnestly I seek you;
I thirst for you,
 my whole being longs for you,
in a dry and parched land
 where there is no water.
² I have seen you in the sanctuary
 and beheld your power and your glory.
³ Because your love is better than life,
 my lips will glorify you.
⁴ I will praise you as long as I live,
 and in your name I will lift up my hands.
⁵ I will be fully satisfied as with the richest of foods;
 with singing lips my mouth will praise you.
⁶ On my bed I remember you;

I think of you through the watches of the night.

⁷ Because you are my help,

 I sing in the shadow of your wings.

⁸ I cling to you;

 your right hand upholds me.

⁹ Those who want to kill me will be destroyed;

 they will go down to the depths of the earth.

¹⁰ They will be given over to the sword

 and become food for jackals.

¹¹ But the king will rejoice in God;

 all who swear by God will glory in him,

 while the mouths of liars will be silenced.

LEARN

Session 6 Video Teaching (13:00 min.)

Gather your group together to watch Lisa's sixth video teaching. You can use the notes section below to keep track of what you are learning.

Date:_____

To realize your potential, you need to remember these promises:

- God is for you and with you (Rom. 8:31).
- God fights for you (Ex. 14:14).
- God loves you with an everlasting love (Jer. 31:3).
- God sees you and knows everything about you, even your thoughts (Ps. 139).
- God is working on your behalf (Phil. 2:13).
- God works all things for your good (Rom. 8:28).
- God is the same yesterday, today, and forever (Heb. 13:8).

God knows what He is doing. Walking a hard
road with God results in holy payoff.

Never fear these things:
- The things that will be your best teachers
- All the "coulds" that haven't happened yet
- The hard moments that only make you better
- People who are human just like you
- Experiences you don't know or share
- Hard-to-swallow things that feed your soul with strength
- Not knowing everything you feel you should already know
- Saying the words, "I'm sorry about that"
- Truth that will set you free
- Things that can't change your relationship with Jesus

God will not leave you, not for one second, to do it alone.

Notes

DISCUSS

Group discussion is the most important part of the study. Take 20–45 minutes to process what you are learning with your group.

1. Look back at your notes from Lisa's teaching and share with your group which of God's promises means the most to you right now and why.

2. What is it about God's changelessness that enables us to grow and change?

3. Look back at your notes from Lisa's teaching and share with your group which nagging fear distracts you most.

4. How would your life be different if you were truly yielded to God right now? In a tangible scenario, what would that yielding "look like?"

5. If you've experienced the hard good, share your testimony of God's faithfulness and the journey of transformation.

6. What will you remember most about this study?

7. If you could send Jesus a thank-you text for choosing to hard good on our behalf, what would your text say?

PRAY

This prayer is for your group leader to pray over your group as a blessing. This is your opportunity to receive a blessing from the Lord before you pray for one another and take prayer requests. Prayer blessings are a biblical practice of loving others by calling on the Lord on their behalf.

> Lord, I pray a blessing of transformation over this group. I pray greater insights, continued willingness to grow and change, and gratitude for even the hard that leads us to the good You have for us. May each one of us be changed by Christ's love and live into our fullest potential.
>
> In Jesus' name, amen.

Group Prayer Requests

You can use this space below to list your group members' prayer requests.

Pray as a group before you close your time together.

Embracing the Hard Good
Personal Study

CONTEXT AND SETTING

I cannot believe we are here, at week 6. David finally becomes king of Israel in the passages we will study this week. You've been so patient to see David's story through his humble beginnings as a shepherd, to a valiant warrior for God, from a humble servant of King Saul to his own coronation as the next monarch of God's chosen people. All the hills and valleys of David's rise to the throne can be a reminder: our stories are inevitably going to have a lot of hard but good can come from it all because God is always working.

I hope in all these weeks you have come to realize this very important truth: God's *purpose* for your life doesn't depend on your willingness, but your *usability* does. In other words, we will be limited in how powerful for the Kingdom of God we will be, *based on how much we let God chisel us* through facing the hard, which in turn produces the good. Did you catch this distinction? It's all about our *response* to our struggles—not constantly seeking some fresh to-do for our lives or spending our lives trying to re-write history or avoid hard things–that leads us to become the person we were meant to be.

As I talk about in the book, The Hard Good, *purpose and usability are two different things.* God's purpose for us cannot be altered and has been predetermined—all believers have the same one: to "go and *make disciples* of all nations" (Matt. 28:19). But we can live below our potential and never see God do the work in and through us that He

wants to do by stifling transformational growth. Let's see how David lived up to his potential with the divided nation finally united under this leadership.

Read 2 Samuel 5:1–12.

1. When the tribes arrived at David's coronation, how did they express their devotion to his leadership in 2 Samuel 5:1?

2. Turn to Genesis 2:21–23 and write out what Adam said of Eve.

 Just as in Genesis during the creation account of Adam and Eve, the people of Israel were proclaiming their unity after a divided kingdom. Also, their declaration symbolized their oneness with King David. They too were as one and as close as a husband and wife team.

3. According to 2 Samuel 5:10, why did David realize his full potential?

4. Based on these Bible verses below, who did God say He would be with?

Genesis 35:2-3	
Genesis 39:21-23	
Exodus 3:11-12	

5. What does Matthew 28:17–20 say about God's presence with you?

6. Describe how the experiences of both Saul and David reflect your own experience of acknowledging God's presence, or perhaps ignoring it.

You can't shake God's presence from your life. He's with you now and forever more. Isn't this the best news? Left on your own, you can't reach your fullest potential. No amount of mustering and powering-through takes us through the hard and into the good God has planned. Only God can do that. He accompanies you all along the way.

God was with Jacob, He was with Joseph, He was with Moses, and He will be with you.

David got this. Believing God's comforting, powerful presence would guide him, David is crowned king of Israel knowing God's nearness will never leave him. I wonder what peace would be released in your life, what level of usability you could live into, if you leaned into God's calling on your life and trusted Him to work out the details. My hunch is you'd be set free in ways that would create flourishing for you and everyone around you the way Jesus' presence in your life is a blessing to you and others.

INTO THE SCRIPTURE

Today you're going to see just how committed God is to your transformation. God is the covenant making and keeping God and it is with that loving devotion He keeps His promises to you and to me. I think once we finally buy into the benefits of the hard good process it's tempting to worry what will happen when we inevitably fail in our mission to change. You have a sacred opportunity today to review God's promise to David that the line of David would carry on forever. In spite of anything David or

his people could do to thwart God's plan or reject God's ways, God is going to remain faithful to His covenant with David. It takes a long time for God's promise to be fulfilled because we don't see the full completion until Jesus comes as the new king to follow in David's footsteps. But God keeps His promise.

As you read more of David's story, consider the commitment God has made to you in the New Testament, to counsel you, guide you, and love you, no matter what. It is cool to see how God used David to rule over the people with justice, to build the temple, to carry on the mission God originally gave to Abraham to bless all nations. But it means more knowing what we know about David's imperfections. If God is steadfast in His love for you, if His plans cannot be undone, if His promises are never broken, you have the freedom to fail forward in your spiritual life.

Read 2 Samuel 7:1–11.

1. Write out what the prophet Nathan said to David in 2 Samuel 7:3.

2. What would your reaction have been had these words been spoken to you (assuming context would be relative to today)?

3. Fill in the blank based on 2 Samuel 7:8–9. David was taken from the pasture as a _____ of sheep to become God's shepherd of people as king.

4. God has been _____ David wherever he went in battle and secured the victories.

5. Based on 2 Samuel 7:16, how long would David's dynasty last?

6. Who is God talking about in 2 Samuel 7:12–15?

Usability will bring you the best life. Being used by God, like David, results in the happiest human beings. No single other thing delivers more joy or satisfaction. It all boils down to allowing your struggles to drive you to your greatest usability for God. The way we get from struggles to usability is through change. And change arrives as we embrace the hard good. David is a great example of this.

Take a few minutes to really look back on your life experience. When were you a mere shepherd of sheep just doing your thing, with zero expectation of being called to more? Can you identify the times God has asked you, or tapped you to step into a role you were not expecting? How did it feel? What did you do? Did you accept the call or did you give it one foot, but not both? This is our acceptance moment, our moment of acknowledging we are created for more and have so very little to do with that. As you journal in the space below, thank God for the times He's asked the hard good of you.

"How great you are, O Sovereign LORD! There is no one like you. We have never even heard of another God like you!" (2 Samuel 7:22NLT)

PERSONAL APPLICATION

God can change you.

No, really. He can.

He can change your mind about things you've thought for years.

Change your mouth about things you've said for so long.

Change your heart about things you've privately held onto.

It's okay to let Him do that. You aren't losing anything by doing it except a part of yourself that hasn't served you well. Your self-protection hasn't protected you—you're still hurting. Your walls haven't kept the hard things out. Your routines of the past may carry the comfort of familiarity, but with that has come enormous wear and tear.

Your words in the past might have been pain talking. Your mind might have prompted you to take escape routes just to avoid the hard roads. Your heart might have been too stubborn to know the good that God knew but you didn't yet.

Will you give God the chance to change the things He knows aren't for your best?

Read 2 Samuel 7:18–29.

1. What does David's opening statement in his prayer of gratitude reveal about his character?

2. Why did David believe the monarchy would last forever? Check all that apply.

☐ Because of God's promise

☐ Because of David's courage and obedience

☐ Because of God's heart

3. According to 2 Samuel 7:22–23, list the ways God is great.

4. Using 2 Samuel 7:27–29NLT as a model below, fill in the blanks with your own story and then read the passage again and hear the truth of God in your life:

> "O LORD of Heaven's Armies, God of Israel, I have been bold enough to pray this prayer to you because you have revealed _____ _____ to your servant, saying, '_____ _____ ,
>
> For you are God, O Sovereign LORD. Your words are truth, and you have promised _____ _____ to your servant.
>
> And now, may it please you to bless _____ _____, so that _____ may _____.
>
> For you have spoken, and when you grant a blessing to your servant, O Sovereign LORD, it is an eternal blessing!"

5. Fill in the blanks:

_____ in my life will _____ because of God's promise.

I will have _____ and I will be _____ because God loves me.

God's heart tells me _____.

RED THREAD REALITY

Several weeks ago, you committed to study God's word and seek the hard good. I'm so proud of your perseverance. As we wrap up our study time, I want you to see the beautiful red thread of Scripture we've been following. Jesus is the red thread, unifying all of God's Word together.

A study of the life of Saul and David often leaves us anticipating relief through the person of Jesus. When we read about Saul's unrealized potential and sketchy leadership, we can't help but wonder when the big problems of the world will be fixed. When we read about David's imperfect success, we have to admit he embraced more hard good than Saul, but the people of God still need a savior. This is a good reminder, friend, that no matter how wise or capable any leader may be, they are not Jesus. He is our hope, our compass, our one and only King, forever—no matter who rises to power in a pulpit, government, or on the internet—Jesus alone remains the only true King who can save.

We've seen how Jesus is better as King than Saul and David both as He is:

1. The ultimate king of all kings to come and rule God's people perfectly.
2. The horn of salvation or the messiah to rescue His people from the problem of sin.
3. The good shepherd that will protect and provide for His people. Someone to guard and lead them into safety.
4. The Son of David that will carry on David's throne forever.

Carrying that red thread to the very end of the Bible—the last book is Revelation. It is a letter to the early churches struggling to find the hard good and it is a prophetic and apocalyptic reminder that Jesus is coming back and will restore everything. Notice how Jesus is referred to in the book of Revelation:

King of Kings (Revelation 11:15)

The seventh angel sounded his trumpet, and there were loud voices in heaven, which said: "The kingdom of the world has become the kingdom of our Lord and of his Messiah, and he will reign for ever and ever."

Horn of Salvation (Revelation 7:10)

And they cried out in a loud voice: "Salvation belongs to our God, who sits on the throne, and to the Lamb."

Good Shepherd (Revelation 7:15–17)

Therefore, "they are before the throne of God and serve him day and night in his temple; and he who sits on the throne will shelter them with his presence. 'Never again will they hunger; never again will they thirst. The sun will not beat down on them,' nor any scorching heat. For the Lamb at the center of the throne will be their shepherd; 'he will lead them to springs of living water.' 'And God will wipe away every tear from their eyes.'"

Son of David (Revelation 22:16)

"I, Jesus, have sent my angel to give you this testimony for the churches. I am the Root and the Offspring of David, and the bright Morning Star."

Spend your last time alone with this study going back through each step of your journey, and as you complete the following statements, let yourself receive the blessing God intends for you as you don't just complete this study, but you open your arms, heart, mind, and spirit to what comes next!

Turn back to Session 1, pages 2–3. Reread Psalm 25. In the space below, summarize how this psalm will help you show up for your life.

Turn to Session 2, pages 24–25. Reread Psalm 39. Write a short prayer about becoming God's woman and what that means to you.

Turn to Session 3, pages 42–43. Reread Psalm 30. Choose a verse from the psalm and write how it will help you specifically as you move past your past. Reflect on it and let the words be the catalyst for your spiritual movement forward.

Turn to Session 4, pages 58–59. Reread Psalm 32. Write one or two things you are claiming back from your struggles; things you will no longer allow to be kept from you:

1)_____

2) _____

Turn to Session 5, pages 76–77. Reread Psalm 17 out loud to yourself, a couple of times. Write it out on a separate piece of paper in the space provided and commit to referring to it every time you want to shut down. Let Psalm 17 be your guide for showing up!

Turn to Session 6, pages 94–95. Reread Psalm 63. Write a prayer seeking to embrace the hard good that has been, could be now, or is yet to come. Let David's words be a template for your own experience of letting God do the transforming work in and through you, for His greatest work yet!

Leader's Guide

Leader, I am such a fan of you. If you have followed my ministry for any period of time, you know of my great love for leaders—I am so grateful for people like you who step up and take on the job of leading important conversations like the one in this study! Know that I have been praying for you, and I think of you, often.

Thank you for your willingness to lead. What you have chosen to do is valuable and will make a great difference in the lives of others. The rewards of being a leader are different from those of participating, and we hope that as you lead you will find your own walk with Jesus deepened by this experience.

The Hard Good is a six-session study built around video content, small-group interaction, and personal study. As the group leader, just think of yourself as the host of a dinner party. Your job is to take care of your guests by managing all the behind-the-scenes details so that when everyone arrives, they can just enjoy time together.

As the group leader, your role is not to answer all the questions or reteach the content—the video, book, and study guide will do most of that work. Your job is to guide the experience and cultivate your small group into a kind of teaching community. This will make it a place for members to process, question, and reflect—not receive more instruction.

Before your first meeting, make sure everyone in the group gets a copy of the study guide. This will keep everyone on the same page and help the process run more smoothly. If some group members are unable to purchase the guide, arrange it so that people can share the resource with other group members. Giving everyone access to all the material will position this study to be as rewarding an experience as

possible. Participants should feel free to write in their study guide and bring it to group every week.

 # SETTING UP THE GROUP

You will need to determine with your group how long you want to meet each week so you can plan your time accordingly. Generally, most groups like to meet for either ninety minutes or two hours, so you could use one of the following schedules:

Section	90 Minutes	120 Minutes
WELCOME (members arrive and get settled)	10 minutes	10 minutes
SHARE (discuss one or more of the opening questions for the session)	10 minutes	15 minutes
READ (discuss the questions based on the Scripture reading for the week)	10 minutes	10 minutes
WATCH (watch the teaching material together and take notes)	20 minutes	30 minutes
DISCUSS (discuss the Bible study questions you selected ahead of time)	30 minutes	40 minutes
RESPOND / PRAY (pray together as a group and dismiss)	10 minutes	15 minutes

As the group leader, you'll want to create an environment that encourages sharing and learning. A church sanctuary or formal classroom may not be as ideal as a living room, because those locations can feel formal and less intimate. No matter what setting you choose, provide enough comfortable seating for everyone, and, if possible, arrange the seats in a semicircle so everyone can see the video easily. This will make transition between the video and group conversation more efficient and natural.

More than anything, I just encourage you to be personally prayerful and open. Your spirit of personal transparency and generosity will do wonders for women who will follow your lead.

Also, try to get to the meeting site early so you can set up your TV screen and

que up the streaming video or DVD and be ready to greet participants as they arrive. Simple refreshments create a welcoming atmosphere and can be a wonderful addition to a group study evening. (But don't stress over this or make it fussy!) Try to take food and pet allergies into account to make your guests as comfortable as possible. You may also want to consider offering childcare to participants with children who want to attend. Finally, be sure your media technology is working properly. Managing these details up front will make the rest of your group experience flow smoothly and provide a welcoming space in which to engage the content of *The Hard Good*.

STARTING THE GROUP TIME

Once everyone has arrived, it's time to begin the group. Here are some simple tips to make your group time healthy, enjoyable, and effective.

First, begin the meeting with a short prayer and remind the group members to put their phones on silent. This is a way to make sure you can all be present with one another and with God. Next, give each person a few minutes to respond to the questions in the "Share" and "Read" sections. This won't require as much time in session one, but beginning in session two, people will need more time to share their insights from their personal studies. Usually, you won't answer the discussion questions yourself, but you should go first with the "Share" and "Read" questions, answering briefly and with a reasonable amount of transparency.

At the end of session one, invite the group members to complete the between-sessions personal studies for that week. Explain that you will be providing some time before the video teaching next week for anyone to share insights. Let them know sharing is optional, and it's no problem if they can't get to some of the between-sessions activities some weeks. It will still be beneficial for them to hear from the other participants and learn about what they discovered.

LEADING THE DISCUSSION TIME

Now that the group is engaged, it's time to watch the video and respond with some directed small-group discussion. Encourage all the group members to participate in

the discussion, but make sure they know they don't have to do so. As the discussion progresses, you may want to follow up with comments such as, "Tell me more about that," or, "Why did you answer that way?" This will allow the group participants to deepen their reflections and invite meaningful sharing in a nonthreatening way.

Note that you have been given multiple questions to use in each session, and you do not have to use them all or even follow them in order. I purposely gave you meaty questions so you would have plenty to dive into, so expect that the answers will take some time! Feel free to pick and choose questions based on either the needs of your group or how the conversation is flowing. Also, don't be afraid of silence. Offering a question and allowing up to thirty seconds of silence is okay. It allows people space to think about how they want to respond and also gives them time to do so.

As group leader, you are the boundary keeper for your group. Do not let anyone (yourself included) dominate the group time. Keep an eye out for group members who might be tempted to "attack" folks they disagree with or try to "fix" those having struggles. These kinds of behaviors can derail a group's momentum, so they need to be steered in a different direction. Model active listening and encourage everyone in your group to do the same. This will make your group time a safe space and create a positive community.

The group discussion leads to a closing time of individual reflection and prayer. Encourage the participants to take a few moments to review what they've learned during the session and write down their thoughts to the "Respond" section. This will help them cement the big ideas in their minds as you close the session. Conclude by having the participants break into smaller groups of two to three people to pray for one another.

Thank you again for taking the time to lead your group. You are making a difference in the lives of others and having an impact on the Kingdom of God! I truly love you so much.

Endnotes

1. Daniel J. Treier and Walter A. Elwell, entry for "Blessing," *Evangelical Dictionary of Theology* (Grand Rapids, MI: Baker Academic, 1997),

2. Tremper Longman III and Raymond B. Dillard, *An Introduction to the Old Testament*, 2nd ed. (Grand Rapids, MI: Zondervan, 2006), 158.

3. Ray Lubeck, *Read the Bible for a Change* (Eugene, OR: Wipf and Stock, 2005), 169.

4. Lubeck, *Read the Bible for a Change*, 169.

5. Lubeck, *Read the Bible for a Change*, 170.

companion book
to enrich your study experience

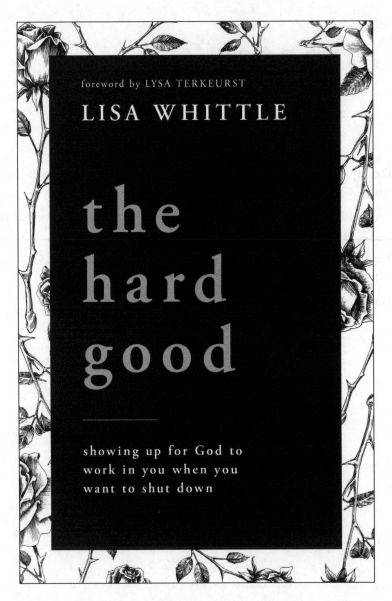

foreword by LYSA TERKEURST

LISA WHITTLE

the
hard
good

showing up for God to
work in you when you
want to shut down

Available wherever books are sold